D1338139

Birdsong

Madeleine Floyd

Birdsong

Madeleine Floyd

BATSFORD

For my son Jonah
and for my parents

May the birds sing for you always.

This edition published in 2018 by
Batsford, an imprint of Pavilion Books Company Ltd
43 Great Ormond Street, London WC1N 3HZ

First published in 2010 by National Trust Books

ISBN: 9781905400973

A CIP catalogue record for this book is available from the British
Library.

23 22 21 20 19 18
17 16 15 14 13 12 11

Reproduction by Mission Productions, Hong Kong
Printed and bound by Toppan Leefung Printing Ltd, China
Design by Lee-May Lim

This book can be ordered direct from the publisher at the website:
www.pavilionbooks.com or try your local bookshop

Contents

Introduction

Birds are very impressive. They fly, they soar, they swoop, they glide and then they alight silently without so much as a wobble. Their bodies are soft to the touch and endearingly stout yet apparently weightless. Dressed in fine colours, like us, birds hop about on their two legs, which definitely encourages our immediate affinity with them. They migrate, often travelling further than we might in a lifetime, to sensibly warmer climates for the winter. With no map to hand, they return safely the following spring to breed. And then they sing! They have earned their reputation as symbols of peace, hope and freedom, and there is not a generation that has not marvelled at their ability and their charm, packaged so incongruously into such a small and delicate frame.

I have always loved birds. There is a humble fidelity in their presence that consoles. Their ability to find something to sing about reminds me that our own existence, whether happy, flat or turbulent, is nothing short of miraculous. One of my earliest memories is waking to the sound of a wood pigeon cooing softly outside my window at my grandparents' home in Somerset. Aged five and fearful of the day ahead (kedgeree for breakfast and a weekend without my parents), I found that serenade was all that I needed. Lying there I realised there was no real need to worry unnecessarily when outside we have feathered choristers cajoling us into action.

Over the years birds have provided good company. Waking at dawn to feed our son, I would find the birds already up and in full voice. Perched aloft, they cheered me and my husband, like football spectators, as we

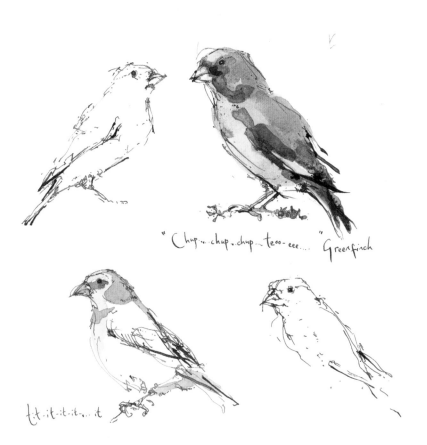

" Chup .. chup .. chup ... tzoo - eee " Greenfinch

t·it·it·it·it·.... it

poured ambition and compost into our first garden. They are the eternal optimists of daily life that I wouldn't like to be without.

I first began sketching birds when I was studying Illustration at Camberwell College of Art in London (see pages 7 and 9 for examples from my bird sketchbooks). Sent into town by my tutor to study Georgian architecture, I preferred drawing the pigeons to pilasters. My first commissioned piece on leaving college was an illustrated cover for the *Evening Standard* Magazine, featuring a dozen London pigeons, and soon after that followed chickens for Sainsburys egg boxes. Perhaps I have felt indebted ever since and so it has been a pleasure to have the opportunity to wholeheartedly celebrate my favourite birds in this book. Learning about the idiosyncrasies of each individual bird has only strengthened my affection for them and I remain a twitcher with a great deal to learn.

As our own world of communication becomes faster and our spoken language becomes truncated, and often redundant, the sound of birdsong is all the more impressive and beautiful. Mobile phone texts now replace flirtatious phone calls and emails often stand in for hand-penned love letters. So it makes me extremely happy to know that amorous birds are still courting through the sound of their song. Why do birds sing? I would love to know for sure. In fact I lie: I'm delighted that we don't know for sure and I hope we never become so informed as to fully understand that mystery. I like to think birds sing for the same reason that they fly, quite simply because they can. I hope we can take inspiration from their simplicity, and as humans do what we can with what we have, and if we feel moved to warble along in life, all the better.

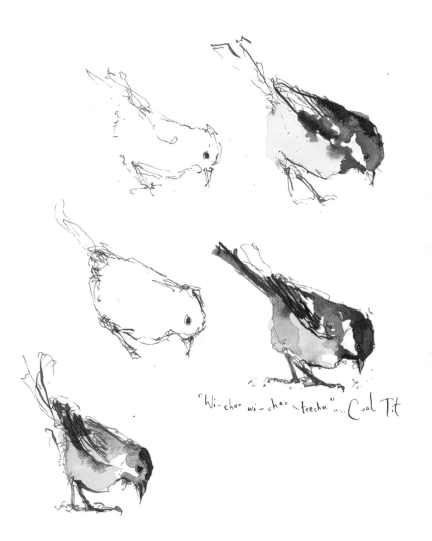

"Wi-choo wi-choo ..teechu".... Coal Tit

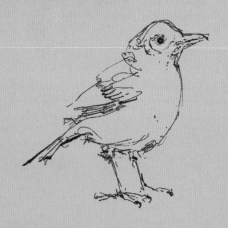

Chapter One
Garden and Parkland Birds

Robin *(Erithacus rubecula)*

Robin Redbreast is loved by many. His song is beautiful and joyous and is sung with all his heart and soul. He is one of the few birds whose song can be heard all year round (with the exception of moulting time in late summer) and he will happily perform his sweet warbling song at dusk.

With a heart rate of more than 1000 beats a minute the Robin is inquisitive and entertaining. He can be found on the edge of woodland, in parks and in gardens, preferring dimly lit and overgrown areas. In Britain he has become the gardener's companion, swooping down to dine on worms in the dug soil. He is, however, known to be aggressive in defence of his territory. In spring the female builds a nest out of roots, stalks and moss. Her mottled brown fledglings leave the nest before they can fly and conceal themselves along the ground while their parents continue feeding them with berries and small insects until they are able to fend for themselves.

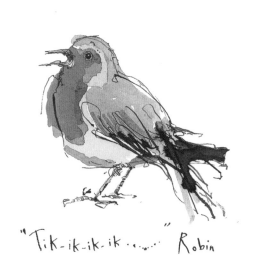

"Tik–ik–ik–ik" Robin

Blackbird *(Turdus merula)*

Europe's most familiar bird, the Blackbird owns perhaps one of our best-loved songs. The confident, full-throated melody of his song is, for many, the soundtrack to spring's arrival. As soon as green shoots are imminent, he bursts into tuneful chorus from dawn until dusk. This keen songster has won our affection and in return he has become our suburban companion.

Originally a woodland bird, the Blackbird is now a common visitor to the bird table and his mate happily builds a nest in surprisingly visible places, such as windowsills, woodpiles and up drainpipes. The bright orange beak of the Blackbird is especially well equipped to assist in pulling up earthworms and these are given by both parents to their young, along with caterpillars, berries and scraps.

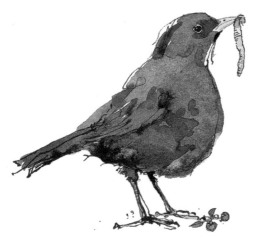

"pink pink pink-pink pink" Blackbird

Blue Tit *(Parus caeruleus)*

Sporting a blue cap and proud yellow chest, the Blue Tit is a much-loved visitor to the garden. His song is loud and high-pitched and ends in a long rapid trill.

Swooping in to a sudden stop on the bird table and often seen feeding upside down on peanut baskets, this bird's acrobatics and agility have earned our esteem. He can be found in gardens, parks and woodland. The female has similar plumage to the male and can lay up to 16 eggs in a single brood. Once the chicks have hatched both parents work hard to keep their hungry offspring well fed with a constant supply of small caterpillars and other tasty morsels.

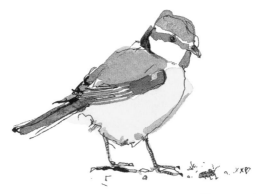

" tsee - tsee - tsee - tsisi tsisisisisisisisi ".... Blue Tit.

Coal Tit *(Parus ater)*

The courting call of the smallest of the Tits is soft
and repetitive and his song is high pitched and bright.

This diminutive but friendly chap prefers to live amongst
tall coniferous trees. As the seasons become colder he takes
on a nomadic existence, often travelling in large flocks
through woods and gardens on a communal quest for food.
He feasts on tiny insects, nuts and seeds and sometimes
stores his food between the tufts of pine needles for a later
meal. In spring the female builds her moss and hair-lined
nest in a tree cavity, among tree stumps or ground burrows.

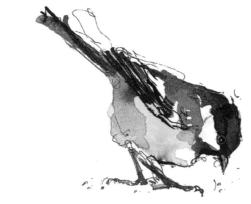

"Wi-choo wi-choo ...teechu"... Coal Tit

Chaffinch *(Fringilla coelebs)*

The loud, cheerful song of the Chaffinch is a welcome sign
of a warmer season. The celebratory melody accelerates
downwards and usually ends with a wonderful flourish of
notes before the song is repeated up to ten times a minute.
The male sings loudly to mark out his breeding territory.

With his pinkish orange chest and his blue bonnet, the
Chaffinch enjoys woodland areas but is equally at home in
town or village gardens. The male brings materials to the
female for the nest, but it is the female who actually builds a
beautifully constructed and compact nest in the fork of a
tree using moss, lichen and spider webs. On the
outside she cleverly uses pieces of bark from the tree to
create a natural camouflage.

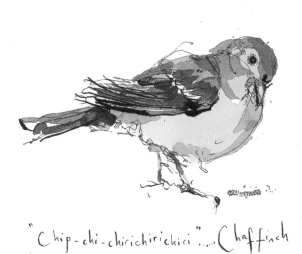

"Chip-chi-chirichirichiri".....Chaffinch

Greenfinch *(Carduelis chloris)*

The elegant Greenfinch visits open deciduous woods
but can also be found in orchards, hedges and large town
gardens. His tune is one of fine staccato trills, slightly
metallic and thin in tone. His song is made up
of a loud rapid twittering on one note followed by
four or five other musical notes, and at times it is
delivered in flight.

The Greenfinch is a sociable fellow and can nest in close
proximity to another pair and on occasion they gather into
large feeding flocks. A somewhat bulky nest of grass and
twigs is usually built among thick bushes or dense tree
branches and is lined with grass, hair and feathers.

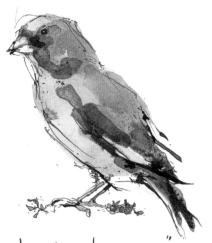

" Chup ... chup .. chup ... tzoo - eee ... " Greenfinch

Bullfinch *(Pyrrhula pyrrhula)*

Easily recognisable by his black velvet cap and rosy pink chest, the Bullfinch is actually a fairly quiet and unobtrusive bird and is sadly declining in presence. The male has a soft distinctive piped whistled call, a gentle but somewhat creaky song and a skill for mimicry, which helped make him a popular ornamental cage bird in the Victorian age. The female Bullfinch has a distinct call. She is chosen by the male and remains for life with her romantic spouse who croons a simple song from late winter to early summer.

The female builds her cup nest of twigs lined with moss and grass towards the end of April, and the male loyally keeps her company as she waits for her first brood of the year to hatch.

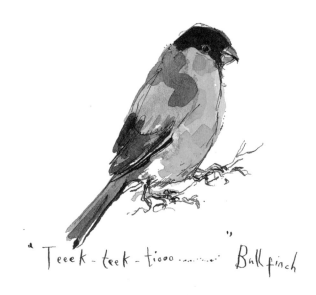

" Teeek - teek - tiooo.........." Bullfinch

Wren *(Troglodytes troglodytes)*

A living adage to the saying that size is not everything, the diminutive Wren is a most determined and impressive singer and his boisterous and full-throated warbling song can be heard loudly across the seasons. His song is shrill and is delivered with real gusto.

One of Europe's smallest birds, often weighing less than 10 grams, the Wren spends most of his time on or near the ground. A sociable little bird, the Wren roosts in groups and is often found in gardens, woodland undergrowth or thickets beside ditches and streams. In spring the male uses plant stalks, twigs and moss to build a number of spherical nests with a small entrance to the side, near the top. The female will then take her pick and the new home is finished inside with soft hair and feathers. The male is relegated to the spare nests for his own sleeping quarters.

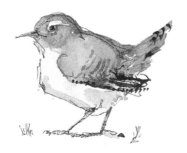

" Chit - chit - chiti - tzerrr........" Wren

Collared Dove *(Streptopelia decaocto)*

The Collared Dove originates from Turkey and has spread
rapidly across Europe at a faster rate than any other
recorded species. His song is a loud, repetitive triple 'coo'.
Depending on one's own mood, it has been described by
some as mournful, monotonous and even irritating, while
for others it offers comfort, calm and a reminder of
early summer mornings.

Quite at ease with humans, this dove sets up home in city
centres or town squares and is a regular guest at bird tables
and windowsills, chancing upon man's goodwill and a free
meal. His nest is built of dry twigs and rubbish arranged
somewhat haphazardly in the branches of tall bushes or
thickets. The successful spread of this prolific bird is due, in
part, to their four broods a year.

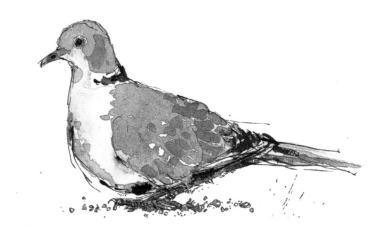

" *Coooo - cooo - coooo ····* " Collared Dove

Song Thrush (*Turdus philomelos*)

So named on account of his loud and magnificent song, the Song Thrush is fully deserving of his reputation as an impressive musical artist, and he belts out a popular rich melody of musical phrases that are repeated many times over. He often delivers his song from a high perch and the overall impression is undoubtedly triumphant.

The resident and migratory Song Thrush can be found across Europe, in gardens, woodland and grasslands. With the onset of colder weather some Song Thrushes fly off to their winter quarters as far as Northern Africa or Southern Europe. Returning in spring, he builds a grassy cup nest, usually low in bushes or hedgerows, and he lines it with mud and dung cemented by saliva. Usually 3 to 5 eggs are laid, and the young are fed on worms, berries and snails. With his beak, the Song Thrush cleverly smashes the snail's shell against an appropriate stone to extract the juicy insides.

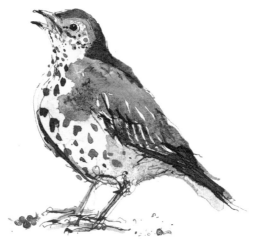

"Tchuck ... tchick ... tchick ...tchick ..." Song Thrush

Mistle Thrush *(Turdus viscivorus)*

The large, bold Mistle Thrush is often the first to celebrate the onset of spring and as a result is one of Europe's most-loved songbirds. His song is long and distinctive. From the end of January, this confident resident and migratory bird arrives at his breeding ground and is ready to perform his loud, wilful song from the top of tall conifer trees. He will happily sing through rain or dull weather and indeed often continues well into the autumn. It may well be that the lofty height from which he orates, and the less favourable weather in which he chants, contribute to an overall distant quality to his far-carrying song, which has just a slight suggestion of sadness in it.

Taller and more slender than the Song Thrush, and usually flying to a greater height, the Mistle Thrush jumps across the ground in long bounding hops. He feeds on insects, fruit and berries and uses a loud call reminiscent of a football rattle to defend his ownership of berry-laden trees.

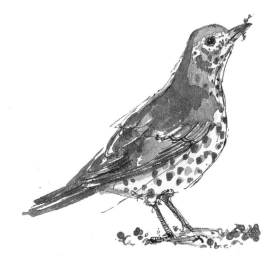

" Turrrk - turrrk - turrrk......" Mistle Thrush

Jackdaw *(Corvus monedula)*

The smallest of the crow family, the Jackdaw is often seen in large flocks and is recognisable by his ash-grey hooded head, unusual pale grey eyes and a very jaunty roguish swagger that only reinforces his reputation as a feathered bandit.

The Jackdaw has a sharp, noisy monosyllabic yapping voice and while not a tuneful fellow he makes up for this with an entertaining talent for mimicry that shows his inquisitive and intelligent nature. The name 'Daw' has been used for this bird since the fifteenth century and is most likely derived, at least in part, from the sound of its resonant call.

Jackdaws seek out holes in trees and old buildings in which to build their nests. Church belfries, church towers and open chimneys are all ideal sites.

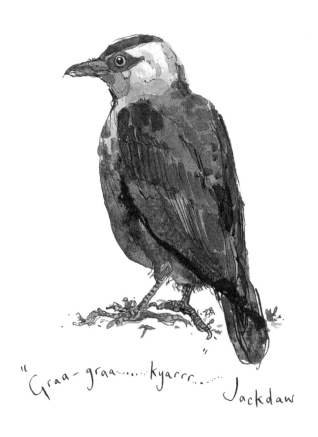

" Graa - graa kyarrr ... Jackdaw

Magpie *(Pica pica)*

The hard, chattering and jeering call of the Magpie is unmistakable. His noisy speech contains a few musical notes but we usually associate this pirate with a raucous and barking call that at times sounds obtrusive and mechanical.

The magpie is a resident mischief, often seen in pairs or flocks and with the supposed habit of collecting glittering objects and hiding them. He also stands accused of sometimes poaching other bird's eggs and fledglings from neighbours' nests, which are eaten to satisfy his opportunistic appetite. Superstition surrounds this elegant and glossy bird, and rhymes dating back to the eighteenth century often mention him as a bad omen.

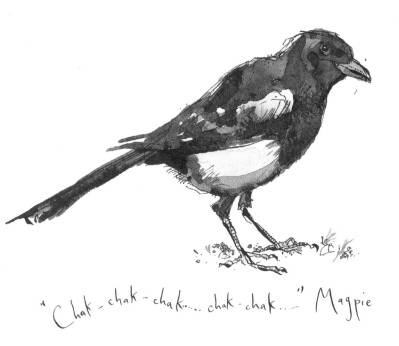

" Chak - chak - chak..... chak - chak....." Magpie

Starling *(Sturnus vulgaris)*

Something of a tearaway, the Starling has a song made up of
an assortment of mismatched squeaks, whistles and
chuckles. He often imitates other birds and is even known to
imitate the sound of a phone ringing. This brash and
cheeky bird calls noisily with high-pitched squeaking before
roosting and is most admirable when seen in numbers.
Winter flocks containing thousands swoop and dive most
gracefully before settling moments later in complete silence
at their chosen destination.

The oily black feathers of the Starling are shot with purple
and green and when flying together in vast numbers they
create an impressive black cloud-like spectacle that is a sight
not to be missed. This rather forceful fellow has been
known to bully other birds over feeding. They build a rather
untidy nest of grass, straw and leaves, usually found in old
holes in masonry or trees.

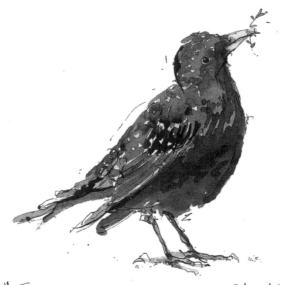

"Tcheer - tcheer.... tcheer.." Starling

Blackcap *(Sylvia atricapilla)*

The cheerful hymn of the Blackcap is often confused with
that of the Garden Warbler. The melody is full of depth,
sweetness and resonance but is usually shorter and slower
than that of the Warbler. It begins with a gentle warbling
prelude, which then accelerates in pace and volume into an
impressive bright change of key. Such musical
accomplishment has brought him the nickname 'King of
the Warblers', but until recently his vocal talent also
meant that he was a much sought-after caged bird
in the Mediterranean.

This shy migratory bird sports a striking black cap
that distinguishes him from all other warblers. His offspring
all wear brown caps until they are mature.
He favours overgrown gardens and dense woodlands with
brambles and briars and builds a rather insubstantial
nest that is usually found near to the ground hidden in
bushes or undergrowth.

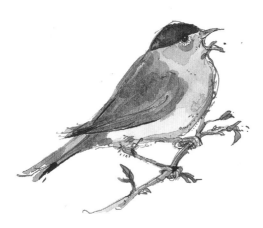

" Tac - tac ... tac - tac ... " Blackcap

Garden Warbler *(Sylvia borin)*

Often praised as the virtuoso of the garden birds, the Garden Warbler is blessed with a remarkably musical and attractive song. Sometimes confused with the voice of the Blackcap, this fellow appears to warble at length without drawing breath and produces an almost clarinet-like pure quality of tone that is loud, rich and brilliant.

Perhaps surprisingly, this musical maestro is rather plainly dressed in greyish brown plumage with dull buff underparts and was only identified at the end of the eighteenth century. He is less visible than one might expect from such an exuberant songster and builds his shallow nest in low thickets or fruit bushes that are adeptly concealed.

In Italy the Garden Warbler is nicknamed 'Beccafico', which means fig poker, reflecting his keen appetite for fresh figs.

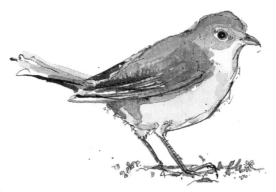

"Chek - chek - chek chirrrr" Garden Warbler

Chapter Two
Heath and Moorland Birds

Cuckoo *(Curculus canorus)*

From the middle of April, you can hear the unmistakably melodious call of the male Cuckoo. His loud, rich and throaty song is unique, reminiscent of a human mother affectionately calling to her children, which perhaps explains our love for him. Strangely, the female emits a loud bubbling call after laying an egg or during courtship. Even in Chaucer's time the 'Cokkow' was renowned for his fine anthem, and many old customs involve the capture of a cuckoo in return for an extension of good weather.

Nevertheless the Cuckoo's sweet crooning belies its incredibly anti-social behaviour, as the female Cuckoo roughly ousts innocent songbird eggs from their nests, replacing them with her own. Once hatched the incongruously large cuckoo chick flexes his squatter's rights and removes contending inmates in order to profit more fully from the menu provided by his charitable, or gullible, foster parents.

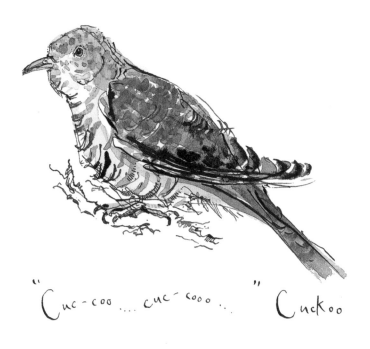

"Cuc-coo ... cuc-cooo ... " Cuckoo

Black Grouse *(Lyrurus tetrix)*

This impressive polygamous bird can be found
across the northern moorlands of Britain and is the largest
of the grouse family. He is famous for his testosterone-
charged communal courting display that takes place each
spring at fixed parade grounds known as 'leks'. Up to 100
virile males gather before sunrise and with inflated chests
and dropped wings they fan out their impressive glossy black
lyre-shaped tail feathers. They hop about, making
competitive threatening gestures at one another, punctuated
by small jerks into the air. Occasionally this macho jostling
can end in broken beaks and war wounds. The birds
accompany this extraordinary performance with a drawn-
out, rolling coo-ing that can be heard from some distance.
As the sun rises the females decide to take an interest
and can be heard gruffly barking as they strut flirtatiously
among the males before succumbing to their
suitor's charms!

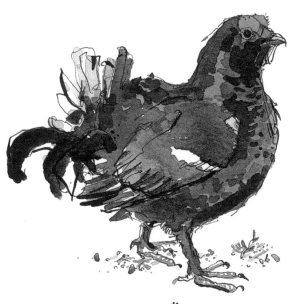

" Tchu-shweee......" Black Grouse

Nightjar *(Caprimulgus europaeus)*

The Nightjar is so named because he sings by night.
His rapid whirring-jarring chant has been described by some
as sounding almost like a small engine revving up with
intent. It contains up to 40 notes per second and rises and
falls in pitch and tempo before slowing down towards the
end as if somewhat exhausted by its initial gusto. Usually the
dry throaty notes are delivered from a branch on which the
Nightjar sits lengthwise unlike most other birds who would
chose to sit perpendicular to their perch.

During the day the Nightjar is well disguised and he lies low,
taking rest along the ground, which makes him a hard
fellow to spot. At dusk he takes to the air with a swooping
flight in order to feed on flying insects that are adeptly
caught in his large gaping beak. Sometimes you can hear an
airborne male as he claps his wings together, creating a
surprising snapping sound.

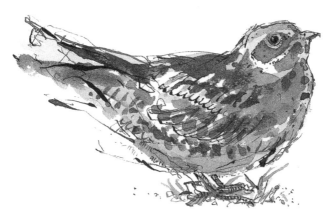

"Churrr churrr chnurrrrr " Nightjar

Dartford Warbler *(Sylvia undata)*

Unlike his fellow warblers the Dartford Warbler braves cold
winters and remains in Britain rather than escaping to
warmer climates. As a result this secretive and elusive bird is
susceptible to decline but he can still be found on the dry
lowland heaths of Hampshire and Dorset.

His song is a quick chattering warble, containing some
brighter notes but usually sung at a fairly low pitch
and often in flight.

A smart little fellow, he weighs no more than a wren
but has an impressively long cocked tail that is half his
overall length. He sports a deep reddish-brown
chest and a red eye ring that looks like a rather
distinguished monocle.

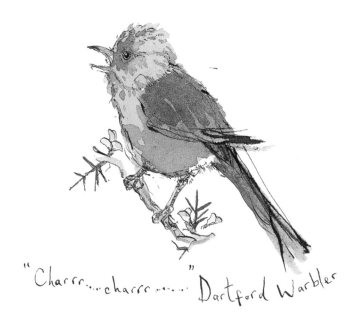

" Charrr....charrr....... " Dartford Warbler

Stonechat *(Saxicola torquata)*

The call of the Stonechat has often been compared to the noise made by two stones being knocked together, and it is likely that this is how he was christened. His rather diminutive song is a chattering, grating warble and he saves a harsh scolding call for moments of alarm.

He is well dressed with a black head, crisp white half collar and a robust russet red chest. These distinct markings and his preference for perching high aloft on telegraph wires or on the crowns of gorse bushes make him an easy bird to spot.

His neat grassy cup nest is lined with hair and feathers and built in the dense grass, sometimes including a covered entrance portico. The female often raises up to three broods of young a year and feeds her chicks on a diet of spiders, worms and other insects.

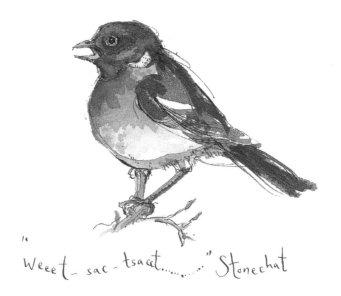

"Weeet – sac – tsacct............" Stonechat

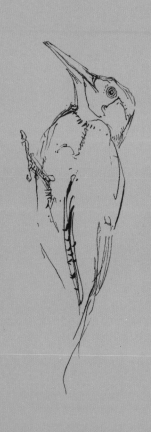

Woodland Birds

Nightingale *(Luscinia megarhynchos)*

The elusive Nightingale is more often heard than seen. A master of timing, he has a flutey song that is unquestionably beautiful, offering variations in pitch and tempo interspersed with guttural croaking and chuckling sounds. He usually performs after dark and can use up to 250 different phrases in his song. Each recital is made up of a unique composition, which has earned him his reputation as one of Europe's most impressive songsters.

The Nightingale was kept as a cagebird in Classical times owing to his great voice, and in Victorian times he would draw crowds of enthusiastic listeners.

Unaffected by such fame, this shy fellow in the wild prefers to go unnoticed, keeping low in thickets and thorny scrub and builds his cup nest out of grass and leaves amongst the bushy undergrowth.

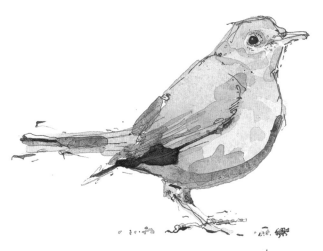

"Wheeet ... wheet tuc-tuc" Nightingale

Jay *(Garrulus glandarius)*

The raucous, laughing call of the Jay and his striking pink
and chequered blue and black plumage are hard to miss.
He's a skilled mimic and can imitate all kinds of other
sounds, often to his own advantage, impersonating
larger birds and other animals to ward off unwelcome
woodland visitors.

Found across Europe, the Jay roams the countryside,
preferring oak woodland for his home. In autumn he hops
across the fallen leaves collecting acorns, carrying them in a
pouch under his throat and burying hundreds beneath dry
leaves and soil in preparation for the cold months ahead.
Indeed the acorns that he forgets to retrieve contribute
significantly to the spread of our own much-loved oak trees.

In the past, the fine feathers of this handsome corvid
(bird of the Crow family) have been collected for use in
millinery and fishing flies.

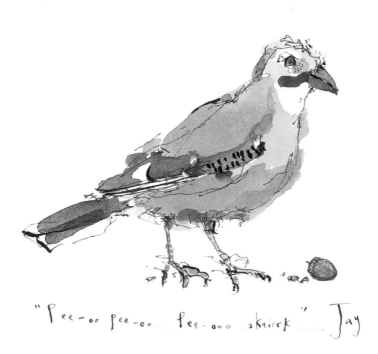

" Pee-oo pee-oo.... Pee-ooo skairrk " Jay

Crested Tit *(Parus cristatus)*

The resident Crested Tit resides in pine forests and deciduous woods across mainland Europe and the Scottish Highlands in Great Britain. Only an occasional singer, the Crested Tit has a soft, rather low rattling trill and can be seen hopping about as he sings.

He is the proud owner of a pointed mottled black and white head crest, which he displays by spreading and closing at times of courtship. This is accompanied by a distinctive if slightly hesitant serenade and a number of endearing courtly bows to his female. Seemingly oblivious to people, he can be watched at close distance. The male often builds his nest from a disused squirrel's drey or by excavating his own soft cup-shaped abode in a decaying tree stump.

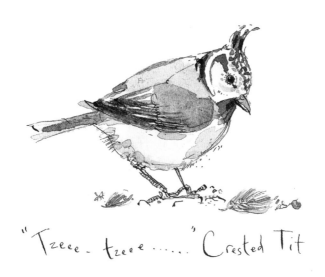

"Tzeee - tzeee" Crested Tit

Green Woodpecker *(Picus viridis)*

The Green Woodpecker has a distinctive loud call and his voice has a laughing ringing tone that has led to the nickname of 'Yaffle' in some parts of Britain.

This suave bird, much rarer than the Great Spotted Woodpecker, sports a vivid red cap and an apple green overcoat that make him a popular and rewarding sight. In flight you can also see his fine yellow rump feathers that contribute to his dapper appearance. He prefers open deciduous woodland and is more often seen on the ground searching for ants with his long impressive tongue than perched high up in the trees as one might expect. Both the male and the female work hard for up to two weeks drilling into the tree trunk to create their nest and sleeping quarters. They then set about raising their young together.

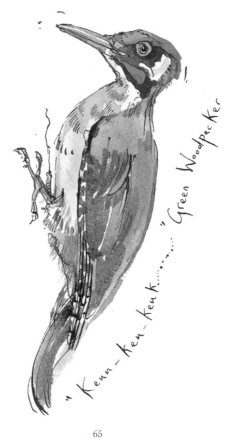

"Kenn—Ken—Ken k……….." "Green Woodpecker

Great Spotted Woodpecker
(Dendrocopos major)

Equally at home in coniferous and deciduous woodland, the Great Spotted Woodpecker is known for his impressive drum rolling as he hammers his bill against branches, often using his tail to grip and act as a balancing anchor as he taps away. The percussion sound is reminiscent of an orchestral wood block. Both the male and the female drum in this way and it is thought to be an audible reminder to others to respect their territorial boundaries. The male's call is a touch jabbering in sound and his musical repertoire is unfortunately non-existent.

An elegant chap, the Great Spotted Woodpecker has a red cap and white epaulettes that stand out against his smart black jacket and buff under parts. During the courtship season he can be seen spiralling around the tree branches, flirting with his confidante and then enjoying mutual flight displays.

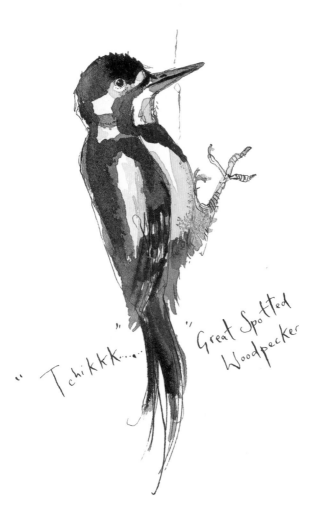

" Tchikkk......" " Great Spotted Woodpecker

Pheasant *(Phasianus colchicus)*

Our best-known resident game bird is actually native to Asia. The popular Pheasant was introduced to Britain in the Roman Age. The current population is largely the result of large-scale rearing in captivity for release into the wild, most notably for game shooting.

The hoarse call of the male Pheasant is loud and explosive and is usually followed by emphatic clucking as he takes to the air. To me, it sounds like the laboured mechanical whirring of wings as if he is struggling to take off from the ground.

The Pheasant usually stays on the ground by day, roosting in trees at night. A debonair fellow, he has a long, slender and tapering tail, held clear off the ground and often cocked upwards. He is dressed in the palette of autumn with a greenish-blue head and glossy conker-coloured chest feathers with ink-black markings. The female is more drab in her colouring.

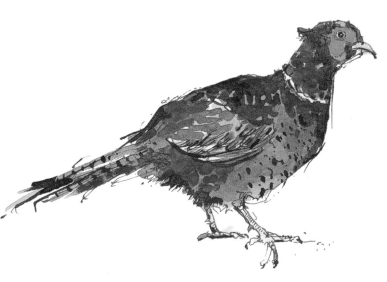

" Korrk-kok korrrk-kok... " Pheasant

Capercaillie *(Tetrao urogallus)*

This resident game bird was formerly extinct but was successfully reintroduced to Britain in the nineteenth century and has survived despite the extensive clearance of so much of the pine forest that he prefers to live in.

A usually secretive bird, the Capercaillie has a prolonged croaking song that accelerates rapidly followed by a cork-popping sound and subsequent hissing and gurgling noises. The female in contrast has a crow that sounds similar to that of the Pheasant.

During his courtship, the male becomes flamboyant and aggressive, and fights regularly break out between sparring males as they establish their hierarchy and select their mates. The hen looks on at the jostling battle from the quiet of nearby branches before waiting to be invited to take part in a duet display flight with her battle-worn cohort.

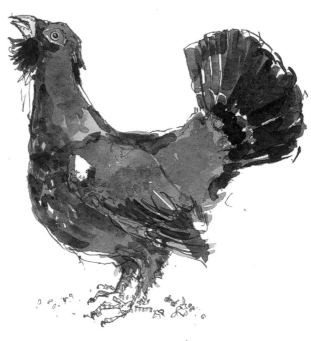

" Tik-up...tik-up.....pop...." Capercaillie

Chapter Four
Farmland Birds

Red-Legged Partridge *(Alectoris rufa)*

The Red-Legged Partridge was first introduced to Britain from France in the late seventeenth century. This attractive gamebird has a low gobbling, chuckling call punctuated by bursts of soft hissing.

He is more likely to be seen running along the ground than flying and cuts quite a dash amidst his arable habitat. With a red bill, white cheeks and a speckled breast the Red-Legged Partridge has beautiful crescent-shaped stripes across his flanks of soft chalky violet, chestnut, black and white, with a soft brown overcoat across his back.

A sociable fellow, he enjoys the company of family and friends. The young fledglings remain in their family groups long after they are fully grown and often bathe and search for food in large groups that make a wonderful sight.

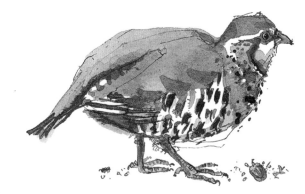

"Chuck... chuck – ar" Red-legged Partridge

Quail *(Coturnix coturnix)*

The petite, migratory Quail is most common across the warmer parts of Southern Europe. He keeps to himself and is hard to see because of his reluctance to take to the skies. His nature is reclusive and he is usually heard rather than seen. He has a resonant, ventriloquist, call that can be thrown far from its source, helping him maintain his privacy. His song has three distinct syllables and has led to many anthropomorphic translations such as 'Wet my lips' and 'Wet my foot'. Perhaps both of these have reinforced his reputation as a prophet for the onset of rain.

The Quail builds a nest in long grass with plenty of cover, and their young are ready to leave only a few hours of hatching. They are able to fly just over two weeks later.

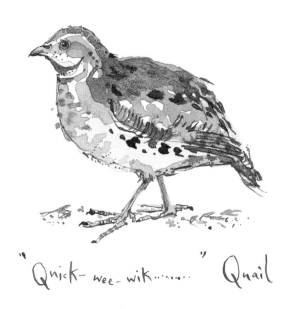

"Quick- wee- wik........." Quail

Wood Pigeon *(Columba palumbus)*

This large and omnipresent pigeon has become such an integrated part of our landscape that he has now set up home in our towns and parks as well as our countryside. Despite his reputation for spoiling farm crops we forgive him much on account of his soft and dreamy cooing song. Consisting of five comforting muffled notes, this bird's song has a depth and rhythm that is much loved, and because of his long breeding season he can often be heard long after the other birds have ended their serenades. His song has led to his Scottish nick-name of 'Cushy-do'.

He is notable for his generous size, and the male has an endearing dance employed during the courtship season where he hops provocatively towards his chosen mate, spreading his tail feathers only to suddenly rise up into the air and then swoop down ever so gently before her in an expression of teasing flirtation.

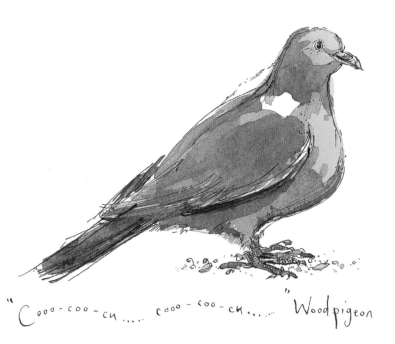

"Cooo - coo - cu cooo - coo - cu" Woodpigeon

Skylark *(Alauda arvensis)*

Without doubt the Skylark is one of the most impressive songbirds. Poets, artists and musicians have all been inspired by this bird's fast, rich, high-pitched song that he belts out with refinement and ease as he soars upward in flight before plunging downwards, whereupon his beautifully choreographed song ceases exactly on cue. Often singing for minutes on end, the Skylark chirrups endlessly and was described by poet George Meredith (1828–1909) as 'a silver chain of sound' for us to enjoy as we gaze awestruck at the ascending flying songster. The Skylark begins practising his fluid song as early as February and is often up before sunrise, perfecting his melody that only improves further as the onset of spring draws closer.

Sadly the Skylark is declining in numbers owing to the increase in intensive agricultural practices, such as the use of pesticides, which result in a lack of winter food.

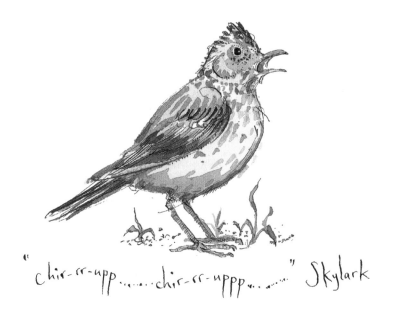

" chir-rr-upp........chir-rr-uppp........" Skylark

Goldfinch *(Carduelis carduelis)*

Clearly identified by his striking black and red face mask and yellow wing bars, the Goldfinch has earned his reputation for being one of our most handsome farmland birds. A frequent and repetitive chorister, the Goldfinch has a song that is twittering and chattering in quality with bouncing liquid trills and a confident final flourish. The male often likes to sing near his nest and the tone is lilting and celebratory.

The Goldfinch is wary in character and is hard to spot but his flight is light and skipping with a bouncy action and, when seen travelling in small flocks, it is an impressive sight. The identically dressed female builds a discreetly camouflaged nest often woven with lichen, leaves and pine needles. She lays a brood of 5–6 eggs and both parents work together to feed their young, usually on seeds adeptly extracted from thistles, teasels and burdock.

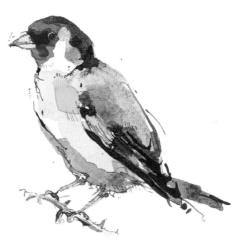

"Swilt - witt - witt - witt......" Goldfinch

Tree Sparrow *(Passer montanus)*

The rare Tree Sparrow can be recognised by his smart chestnut cap and the black marking on his white cheek. He can be found across Europe and Asia, and even as far afield as Japan.

His chirruping and cheeping song is loud and bright. As early as February the female perches aloft and flutters her wings, uttering her soft mating call to attract her partner. The couple select a nearby tree hollow and build their dome-shaped nest out of straw and grass. Both parents take turns to incubate their eggs.

Sometimes settling in suburban areas, the Tree Sparrow usually prefers arable farmland where he can make good use of any spilt grain on the ground. Unfortunately this amicable bird has suffered a dramatic decline in population over the last few years because of the changes in our farming methods.

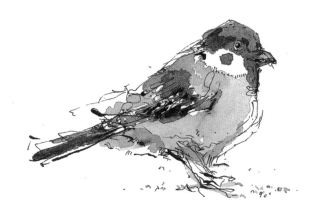

" Tek - tek ... tek - tek" Tree Sparrow

House Sparrow *(Passer domesticus)*

The resident House Sparrow is a bird we all know and love.
Most of us have memories of feeding these perky fellows
with crumbs at some time or other. Perhaps the fact that
they choose to nest in and around our buildings has
contributed to our affection for this bird. They are in part
dependent on us for food and shelter and it's no
coincidence that the cockney slang for 'a male friend' has
always been 'my old cock sparrow'.

The ditty of the House Sparrow is persistent, lively and
chattering. His song consists of much chirping and
twittering as befits this cheeky mischievous character.

Although House Sparrows remain as established couples
in public they are also known to have illicit offspring
following private infidelities!

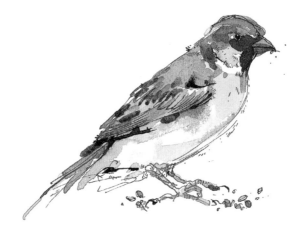

"Cheeep.... cheeep...." House Sparrow

Rook *(Corvus frugillegus)*

The noisy cawing voice of this corvid (bird of the Crow family) is raucous and resonant. Set at a similar pitch to that of a crying baby, it is an impossible call to miss. This large bird flourishes in areas of mixed farming and is most often heard en masse, chatting voraciously as they build their breeding colony of nests high up in the bare winter branches. Glossy black in appearance, the Rook is distinguished by his rather fluffy thick black trouser feathers and the bare-faced patch at the base of his tapered bill.

Large bulky cup nests of sticks are cemented together with soil and lined with leaves and roots. These rookeries are notable for their sense of commotion and up to 50 nests can be found in one colony. Farmers often fight a losing battle with this notorious bird's appetite for corn and this bird's thefts led to the introduction of the scarecrow.

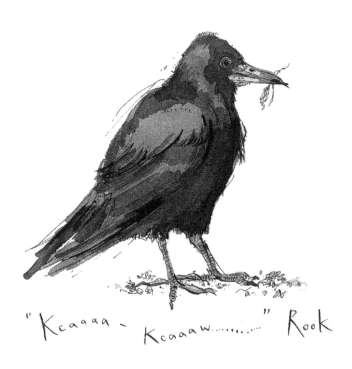

" Kcaaaa - Kcaaaw..........." Rook

Chapter Five

Marshland and Meadow Birds

Kingfisher *(Alcedo atthis)*

Found across Europe, the Kingfisher cuts a dash with his electric blue plumage and rusty-orange under feathers and is dazzling when seen in flight. For me, seeing this elegant glossy fellow is always a cause for celebration. His song is simple with sweet high notes that trill in the spring.

Surprisingly petite, he is usually spotted taking a dramatic dive into the water in order to catch fish for himself or his young. Both the male and the female use their beaks and feet to laboriously dig out their nest over several days. It consists of a deep tunnel set into the steep bank side, which soon becomes littered inside with uneaten fish remains. Kingfishers feed on water insects and small fish that are often caught adeptly in their bills before being swallowed whole.

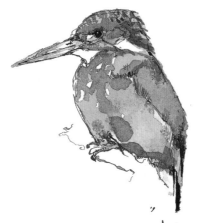

" Che-keee........... " Kingfisher

Redshank *(Tringa totanus)*

One of Britain's most frequently seen waders and recognisable by his bright red legs, the Redshank is notorious for his noisy and vigilant ways. He can be found across salt marshes, mud flats, wet meadows and small creeks. He is almost neurotic about protecting his eggs and fledglings and to this aim he uses resonant bouncing calls to ward off intruders. Similarly, he takes great trouble in weaving a canopy of grass above the nest to prevent eggs from being washed away by high threatening tides.

The Redshank roosts in large flocks but tends to remain apart from other waders. The male builds the base of the family nest, carefully positioned out of sight amongst the marshland grasses, and lets the female perfect the interior.

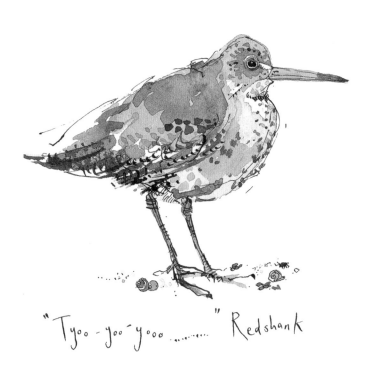

"Tyoo - yoo - yooo" Redshank

Yellow Wagtail *(Motacilla flava)*

The Yellow Wagtail is one or our more beautiful and colourful summer visitors to Britain. He breeds in marshes, water meadows and in damp grassy fields, often residing beside large livestock who helpfully dislodge insects, providing a steady flow of food for this cheerful bird. With his striking bright yellow underparts, green overcoat and black legs, this fellow has a loud, flat yet full voice with a song made up of brief repetitious chirping phrases.

The female builds the nest on the ground. It is usually concealed in a clump of grass and adeptly lined with soft animal hair and small feathers. She feeds her young fledglings on small insects and invertebrates that she finds through constant foraging as she runs through the grasses.

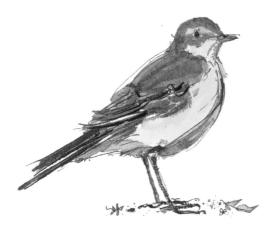

"Tsweeep... tweep......." Yellow Wagtail

Pied Wagtail *(Motacilla alba)*

The migratory Pied Wagtail can be found across Europe,
Asia and Northern Africa. He is a busy character forever
bobbing and 'wagging' his slender tail up and down as he
gives chase to small insects across the ground. His song is
loud and musical and mixes trills with sweet calls to produce
a slight but nevertheless enjoyable warbling chorus.

He is easily distinguishable and is stylish with his
monochromatic dress sense. He has a black crown, nape and
throat and a whiteish eye mask and underparts with flanks
that appear to have been smudged in charcoal dust. In winter
his black feathers fade to a dark grey.

Both the male and the female build a cone-shaped nest
from reed stems, roots and leaves – usually found in
convenient rock cavities along stream banks or in similar
holes found in old buildings or masonry.

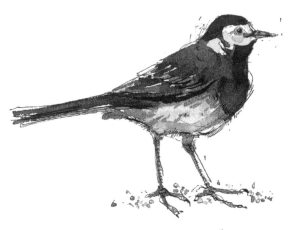

" Chripp ·········tchizzicc·········" Pied Wagtail

Grey Wagtail *(Motacilla cinerea)*

The largely resident and elegant Grey Wagtail owns the
longest tail of the Wagtail family and has black and smoky
grey upperparts with a sulphur yellow chest. This attractive
palette contributes to an air of a gentleman. His call can be
loud and sharp but his song is made up of chirruping flutey
notes and fast trills and warbles.

He is happiest living beside a mountain stream, enjoying
the rocky terrain but can make his home in other
waterside locations as long as there is running
fresh water nearby, from which he can catch water insects
and mayflies to feast on.

His flight is fast and graceful and he lands lightly with an
appropriate bobbing of his long tail.

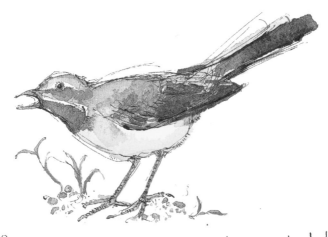

"Szeeeseeee szeee ..." Grey Wagtail

Meadow Pipit *(Anthus pratensis)*

The Meadow Pipit is adaptable in his choice of home, living
at a wide range of altitudes from sea level to 3,000 ft and
above. The courting male makes impressive song flights,
rising rapidly before gliding down to the ground still singing
all the while. His fast piping song increases as he rises then
slows on descent before ending with a trill on landing. His
tone is described by some as plaintive, even anxious, and his
alarm call is squeaky and sharp.

Like the Skylark, this fellow is rather nondescript in
appearance with brown and grey streaks and is often
only distinguished by the unusually long hind claw
on his orange-brown legs.

Unfortunately, despite his attempts to conceal his nest, the
Meadow Pipit is a favourite prey of the cuckoo and often has
his own eggs ousted from his nest by the garrulous intruder.

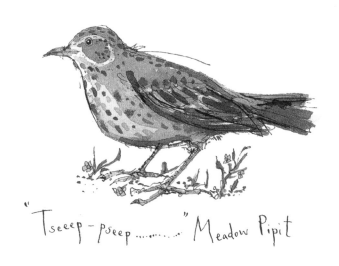

"Tseeep - pseep" Meadow Pipit

Swallow *(Hirundo rustica)*

Eating and drinking as he flies, the Swallow is rarely seen
on the ground, preferring an almost constant airborne
life. His voice is pleasant and twittering and his songs
sound conversational and slightly squeaky with a
limited tonal range.

The Swallow is a keen and agile aviator, graceful and
swooping in flight. I have fond memories of watching
swallows in flock as they expertly ascend and glide in a
manner that seems to illustrate the idea of reaping
the rewards of hard endeavour.

The migratory Swallow is handsome in appearance with
midnight blue upperparts and creamy buff underparts. His
throat and forehead are a regal red and he is best
recognised by his long, fork-tailed streamer feathers.

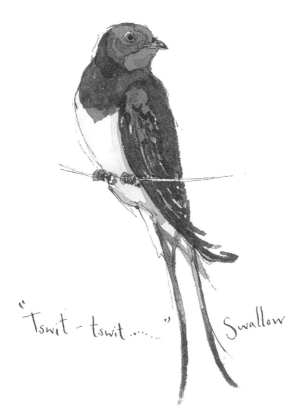

"Tswit - tswit" Swallow

Sedge Warbler *(Acrocephalus schoenobaenus)*

The Sedge Warbler is a summer migrant who lives at the edges of our ponds and riverbeds and can also be found amongst our boggy marshland. His song is sung with determination and is often compared to that of the Reed Warbler. The Sedge Warbler is perhaps more the exhibitionist and his song is interspersed with impersonations of other birds, blended together with warbles, trills, whistles and whirring musical notes to create a widely varied arrangement.

An elusive fellow, he prefers to keep a low profile in amongst the reeds and grasses. He is olive-brown in colour with a notable cream stripe above his eyes.

During courtship the male makes impressive display flights, ascending in song and then spiralling down, with both his wings and tail feathers fanned out to impress his intended mate.

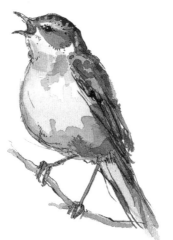

" Tuc - tuc - tuc ... " Sedge Warbler

Bearded Tit *(Panurus biarmicus)*

Originally from East Asia, the Bearded Tit is a reclusive little
bird who spends all his life nestled in the reed beds. His voice
is clear but sporadic and he often prefers silence over song
but can sometimes be heard uttering a soft chattering verse
and the odd repetitive, ringing chorus.

The Bearded Tit has bright yellow-ringed eyes, a soft grey
head and jet-black mandarin whiskers either side of his beak,
which gave rise to his misleading name. He is a nimble
fellow, hopping up and down the reed stalks. He successfully
moderates his diet to accommodate insects in summer and a
seed and vegetable diet in winter.

Unfortunately, he is susceptible to hard winters and
struggles to survive when there is heavy snowfall. In his
favour he is a prolific breeder with up to 4 broods
a year, which helps secure the presence of this
beautiful bird in Britain.

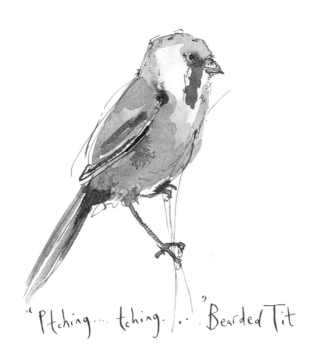

" Ptching.... tching. . . " Bearded Tit

Lapwing *(Vanellus vanellus)*

The elegant Lapwing is widespread across the European countryside and owns a fine head crest of spiky black plumes that make quite an impression. The exuberant courting males perform wonderful flappy, looping 'sky dances' during the breeding season and this is accompanied by the sound of their loud throbbing wings.

As a singer the Lapwing owns a very distinctive high-pitched song that is somewhat nasal and slurred. His tune is similar to that of a swannee whistle with flirtatious phrasing that almost duplicates our own wolf whistle.

Both partners build their shallow hollow nest on the ground and each take it in turn to sit on the eggs until they hatch. One of their more comical traits is the way they tap their large feet on the ground to attract insects and earthworms from the soil, which are then gobbled up.

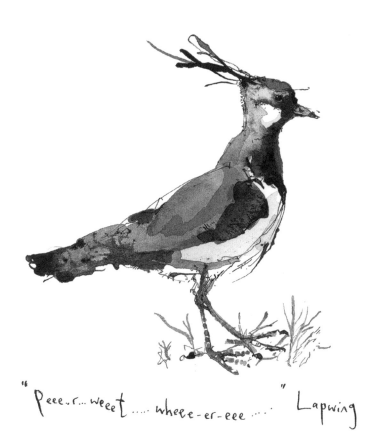

" Peee..r...weeet wheee-er-eee " Lapwing

Common Sandpiper *(Actitis hypoleucos)*

The migratory Common Sandpiper prefers a freshwater habitat and usually resides in small groups of no more than ten. His call is fast and trilling and his voice has a shrill high-pitched but melodic tone.

His feathers are streaked tawny-brown and both the male and female are similar in colour. He is happy to roost alongside other waders and uses his long probing down-turned curved bill to dig for his menu of worms, insects and small molluscs.

The Common Sandpiper's nest is built in a shallow hollow or scrape in the ground and usually a brood of four eggs are incubated by both parents. These young chicks are ready to leave the nest once dry and are able to swim and dive underwater almost immediately. Two weeks later they begin flying and by four weeks they are fully independent.

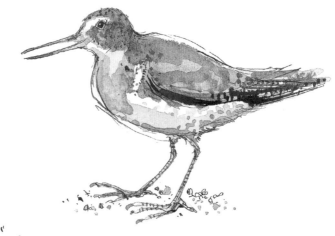

"Tidi-weetii... tidi-weeti" Common Sandpiper

Chapter Six

Coastal
Birds

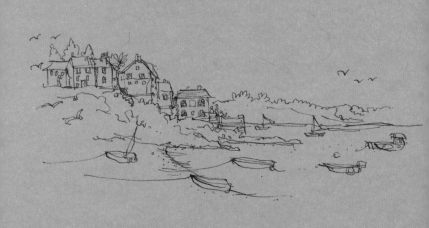

Oystercatcher *(Haematopus ostralegus)*

The Oystercatcher is often found along our coastline and waterways. Bold in voice and body, this stout bird is usually seen probing the shores with his red bill for cockles and mussels but has rarely been seen to polish off an oyster despite his name. They congregate in numbers, and their brash ways and enormous tight flocks create, en masse, an incredibly loud chorus of strident piping trills. In tone his twittering reminds me of the squeaking sound when energetically cleaning glass.

During courtship this fellow can be seen running along the sand behind or beside his intended mate in the hope of winning her affection and deterring his rivals. He breeds happily on most stretches of the British coast and is slowly moving inland too.

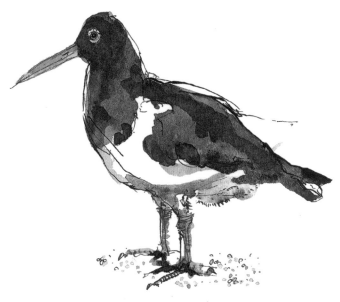

" Kleeep-a-kleeep..... " Oystercatcher

Little Ringed Plover
(Charadrius dubius)

Usually seen busily chasing insects across coastal and river shingle beds, the plump Little Ringed Plover is a relative newcomer to Britain. His call is short, abbreviated and whistled, with a rolling tone like that of a small gull.

During their courtship display the enamoured female shelters under the male's outspread tail. This action is repeated, making it appear like a coquettish dance. When threatened, the Little Ringed Plover wisely fluffs out his feathers in order to present an exaggerated impression of his size and girth.

Both the male and female look similar with a brown crown and a distinctive black headband across their foreheads. Their upperparts are sandy brown and they have white underparts with orange-pink stockinged legs.

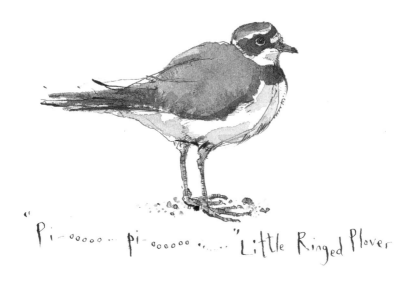

" Pi ˗˗˗˗ ₒₒₒₒₒ ˗˗ pi ˗˗˗˗ ₒₒₒₒₒₒ ˗˗..... "Little Ringed Plover

Avocet *(Recurvirostra avosetta)*

The Avocet's profile is well known as the proud emblem of the RSPB. This elegant bird has a clear piped call with high-pitched rhythmic repetitions that accelerate when alarmed. He thrives in small colonies, largely on the east coast of Britain, and is an inspiring success story for conservationists, having almost become extinct in the last century.

He has an aristocratic air with a black hood and wing markings that contrast forcefully with his bright white plumage. He can often be seen resting effortlessly on one leg and has a remarkable narrow, upturned and elongated bill. He sweeps this bill from side to side, sieving tiny shrimps and invertebrates from the water to eat.

During the breeding season pairs of Avocets indulge in jostling and threatening poses to assert their own hierarchy within the flock.

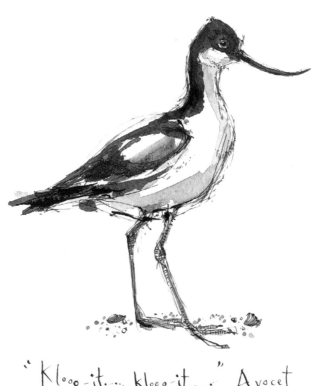

" Klooo-it.... klooo-it...." Avocet

Sanderling *(Calidris alba)*

The Sanderling does not breed in Britain, preferring high
Arctic ground, but he is a welcome winter visitor and passes
through on his migration in spring and autumn. His song is
a shallow, short chattering that reminds me of cackling
laughter. His tone is sharp and squawking and he is usually
seen darting nimbly in and out of breaking waves on the
shore. He searches adeptly for small molluscs and
crustaceans while avoiding being swept away in
the tidal current.

He is dressed in a speckled array of pebble greys in the
winter and muted browns in the summer with a bright white
chest and underparts. Young Sanderlings have a pinkish
tinge until they are fully grown, and they hop about on slim
black legs and have straight black bills.

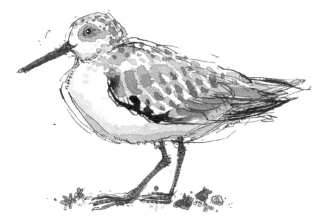

"twik-twik-twik......" Sanderling

Curlew *(Numenius arquata)*

The Curlew is Europe's largest wader and he is the owner of a memorable anthem. His song is throaty, loud and ponderous. His name derives from the sound of his call, 'Coor-li', which he repeats with an accelerating tempo. There is a definite haunting melancholy to his call that can often be heard for much of the year, long after other birds have put away their music. The sound seems to express beautifully the reflective nature of our coastal landscape and lonely moorland.

He arrives at his breeding grounds in early spring and his song flights involve an impressive take-off and descent with uplifted wings that give an appearance of enviable weightlessness. He has an amazing long down-curved bill, brown marbled upperparts and long grey legs.

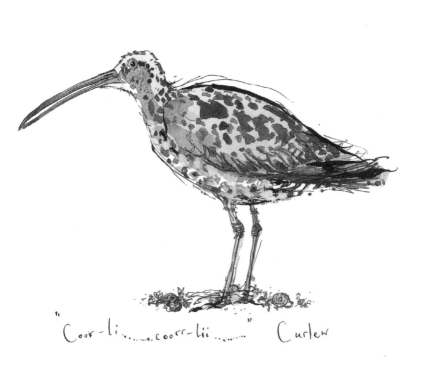

"Coor-li..........coorr-lii.........." Curlew

Bibliography

Birds, M K C Scott
Thomas Nelson and Sons Ltd, 1950

Birds Britannica, Mark Cocker and Richard Mabey
Chatto & Windus, 2005

Complete British Wildlife Photoguide, Paul Sterry
Harper Collins, 1997

Field Guide to the Birds of Britain
Readers Digest, 1981

Heligan Birdsong
Heligan Gardens Ltd, 2000

The Illustrated Encyclopedia of Birds
Treasure Press, 1991

RSPB Birds of Britain and Europe
Dorling Kindersley, 2002

Songbirds
Hamlyn, 1980

'Chirp! Birdsongs of Britain and Europe'
iSpiney Software

Index

127